Poetry and Photography

THE FRENCH LIST

Poetry and Photography

YVES BONNEFOY

Translated by Chris Turner

LONDON NEW YORK CALCITTA

www.bibliofrance.in

The work is published with the support of the
Publication Assistance Programmes of the Institut français

Seagull Books, 2017

First published in French as *Poésie et photographie* by Yves Bonnefoy

© Editions Galilée, 2014

First published in English by Seagull Books, 2017

English translation © Chris Turner, 2017

ISBN 978 0 8574 2 425 9

British Library Cataloguing-in-Publication Data

A catalogue record for this book is available from the British Library

Typeset by Seagull Books, Calcutta, India
Printed and bound by Hyam Enterprise, Calcutta, India

CONTENTS

Editorial Note

'Poésie et photographie' was originally delivered as the *Lezione Sapegno* for 2009 at the University of Val d'Aoste. The text of that lecture was subsequently published by Nino Aragno of Turin, Italy. The present version is a greatly amended and developed version of the original lecture, which it supersedes.

*

There are no footnotes in the French original. The footnotes in this edition have been provided by the translator.

POETRY AND PHOTOGRAPHY

I

'Poetry and Photography: Daguerre, Mallarmé, Maupassant and the Surrealists'—this was the theme I initially set myself, but when I began to put the different parts of the argument together, it soon became clear to me that I had first to lay out the hypotheses, few in number, that will underpin the central idea. This is what I am going to do first, reducing correspondingly the space I would have devoted to Mallarmé and Breton, but not that which I shall accord to Maupassant. The reasons for this will become evident.

This research I am beginning—on the impact of the earliest photography on the experience of the

world and the conduct of existence in the nineteenth century and up to our own day—must necessarily also be a reflection on poetry, since the study of what I shall call 'the photographic' enables us better to understand both how poetry has developed and the tasks that confront it. The kind of—historically unprecedented—act the photographer has accomplished, and continues to accomplish, in fact exerts its influence directly on what poetry is seeking to be. And poetry, in its turn, must therefore examine what that act is, and what it asks of, or imposes on, contemporary society. And it mustn't hesitate to express its reservations, concerns or, indeed, its approval when presented with the diverse and perhaps contradictory forms which that activity has taken since its earliest times, in the days when Baudelaire's intuitions were beginning to dispel the—once again so feverishly religious—illusions that had encumbered Romantic poetry.

But, first of all, these few preliminary remarks on poetry, the fundamental nature of which ought properly to be recalled, even if I can do so today only very summarily. Poetry is what evinces unease at the constructions erected over the centuries by conceptual thought, that thought which bases itself on aspects of the empirically given—from which it deduces laws—but not on the totality, the compactness which we nonetheless perceive spontaneously in things when we encounter them in the here and now of our lives. That kind of conceptual approach, which proceeds by choosing among those aspects—and, hence, simultaneously simplifies and generalizes— deprives the mind of recognizing, within what it perceives, the unity that is the way its various parts breathe together or, in other words, that quality which makes of it a particular, finite thing, even as it opens itself up to that other whole that is reality as such. And this is a blindness that also affects the

self-consciousness of persons, who can no longer fully think their belonging to the being of the world. Poetry is the memory of that loss, an effort to re-establish the lost contact with that which is.

How poetry goes about achieving this task isn't my subject today, though let me make one comment on what it is aiming to re-establish. This is a relation of persons to their environment that would provide the needs and intuitions of the body—as much as those of the mind—with their place in consciousness: a body that is both alive and destined to die. Freeing itself from the many systems that conceptual thinking is only too ready to build as a home for those who accept its simplified representations—churches, for example, armies, sets of values peculiar to commerce or industry—poetry's role is to examine, in a critical or supportive spirit, the ways in which the men or women of our time combat the alienation they undergo.

These ways are many and varied, but they are unified, nonetheless, by a procedure they have in common. Conceptual thought develops within an overall idea of the world, within what I shall term a world-in-image, a schematic world, both underpinned and explicated by a certain use of language that congeals utterance into its categories and projects. And the persons stifled in this way often believe it sufficient, if they are to recover their difference, simply to work on the signifiers of that language 'in image', to appropriate them for their own standpoint, apportioning to the main figures this thinking offers them characteristics that ensue from what they are in their particular existences. For example, for the idea of a tree in general, they substitute the evocation of some tree that they love, this being brought to mind by certain of its aspects. This is to personalize the collective image. But we should beware here of the following danger: operating with the words of the grand image

shared by all, this work on the part of the individual can only be the production, once again, of a similar schema; confinement again within just one image. And poetry has to be aware of this trap, into which it falls too easily, and has to learn, in order to expose it, to recognize its nature and characteristics.

What are these characteristics that distinguish the image from fully lived life? The first is that every image requires a support—wall or stone or canvas or paper, or at least the idea of such a support. And this is so because the support immediately means a delimitation, a framing, which suggests that the things and beings the image seems to evoke are situated in an authentic place, with its own space and even its own light. The frame confers a semblance of reality on the image, and it is from the frame that this illusion derives its capacity to endure beyond the moment of reverie. It confers credibility on it, but first and foremost it confers authority, at a level

we might call ontological—the level at which deci-
sions are made regarding what is and is not. From
which it follows, indeed, that the usual complement
of the frame, in the image that it renders credible, is
a certain point among the figures which seems to
provide the foundation for the *being* the image
claims to possess. This is the case with Pharaoh's
daughter in Poussin's *Moses Saved from the River*: she
is a beautiful, standing figure, full of authority and
the very centre, we might believe, of the harmonious
proportions which present themselves as reality in
the conception this picture has of it.

The fact remains that no image structure is com-
plete reality. This schematic representation may
gather up a great deal of the appearance of things, but,
first, it inevitably leaves outside itself, for example,
that which conceptualization suppresses and wishes
to forget—namely, the finitude within what is, and
the way of seeing the world and life of those who

haven't forgotten their own finitude. The image cannot express this inwardness of existing beings, which is, indeed, essentially temporal.

And it is a fact that in many images the hint of a level—their unconscious—peeps through, at which there is still an awareness of that limit, and the idea that a world exists outside those images. We even see them attempting to ward off this 'outside' by heading off the encounter with it and striving to convince themselves that nothing in it will elude their idea of the real: that nothing in it will manifest that element of chance which is what they fear most. There is, in fact, no room in images for chance. What might seem to signify such a thing has been surreptitiously removed. The folds in the Virgin's gown in an altarpiece, the cat that seems to be present by chance in an *Annunciation* by Lorenzo Lotto are, in fact, the product of the needs, desires and fatalities inherent in the painter's dream. There is no

element of chance in the field of the image! This particular throw of the dice has truly abolished it.[1] Yet chance exists, nonetheless, at the margins of the work in the daily existence of its creator, and, as a result, the image, however affirmative it may be, always has an underlying disquiet to it, which, we might surmise, may even be what lends some paintings their restless, fevered beauty.

II

And I shall now observe that this disquiet of images, this foreshadowing within them of the ineradicable reality of what remains outside was, more intensely than ever, the experience of some great artists of the Age of Enlightenment.

Why was this? Because this project of submitting the knowledge of the world and existence to reason was also a project of dismantling the myths that had built, explained and justified worlds without the aid of that reason. Yet, with myths disappeared also what enabled religion to exert its control over all the regions (even the most nocturnal ones) of reality and life, and which set thought at the

edge—or almost—of the abyss, with a sense of vertigo or anxiety that the great art of the age was able to express; the dizzying sense that there was no longer any foundation for the moral values that had, up to that point, been buttressed by the divinity; and the sense that, henceforth, genuinely human responsibility would have to be assumed. This is what Leopardi and Goya experienced; it is what shows through in the works of Sade.

Then, in the Romantic period, the darkness simply grew and spread—and the vertigo with it— even if the poets of those years attempted to recover their poise by way of religion, with representations and forms of belief of their own private devising. This effort is what Keats and Hugo or Nerval have, more or less, in common, together with Novalis and Casper David Friedrich. It is not enough, however, to deliver Delacroix from his 'lake of blood' obsession, as Baudelaire rightly saw:[2] in vain would that

tormented painter claim to be a follower of Apollo. Around 1840, everything was ready for the development of a more intense—and also more resolute—awareness of the vast 'outside' of the image: of non-being. A crystallization such as Stendhal expressed in 1822 in respect of love, perhaps seeking in that way to deflect attention.[3]

And it was indeed in these same years of the middle of Baudelaire's century that a crystallization occurred that was quite different from that of the thinking of the lover—or self-styled lover. The precondition was an event which, we should note, was immediately celebrated with astonishing—both secular and religious—solemnity. It was on 7 January 1839 at the French Academy of Sciences that François Arago announced to the world the invention of what would be termed the daguerreotype, a procedure by which representations of things from the world around us were permanently fixed on a

support—in this particular case, a copper plate. Fixed! This was not yet, therefore, what photography would make possible. It was merely direct image-capture, affording no possibility of reproduction— that wouldn't come for another ten years. But that is of little consequence. What constituted an event was that there was to be found on the copper plate a full, exact reproduction of what could previously only be met with in three-dimensional form. And hence the 'outside', the realm of perpetual change, has been ensnared and is going to remain here, immobilized, in this very singular new image.

Why is fixing so important? Why am I going so far as to say that this immobilization was as crucial an event as the transporting of external reality into the image? Because it is what enables things which might each merely be considered in itself and on its own to cohabit on a sustained basis with others captured in the same way and hence leave their plane

of shifting, temporal existence and come to exist on the plane of images—that is to say, at the level where images assert their claims. We should note that seeing something at a point other than where it actually was wasn't absolutely novel in Daguerre's day. There had for many years been situations in which an 'outside' had been captured without the intervention of an artist; the surface of the moon, as it could be seen through Galileo's telescope, is one example. But the representations produced in that way weren't immobilized in a frame; they couldn't, therefore, compete with traditional images, which possessed such a frame and hence the power, as I have remarked, to suggest that the scene they showed had reality and being—indeed, a higher nature of being than our own. And now, with the daguerreotype and, shortly after it, the photograph, which were fixed and framed, these representations had slipped in among the images.

Now—and here, as I see it, is the important, indeed essential, element of the event hailed by Arago, who, like Galileo, was an astronomer—these new images take their place among the others only when they have in them something the old images knew nothing of and never wanted to know anything of: namely, chance—an element of chance that was, in this case, wholly unfettered and fully, rightfully itself.

III

How could this be? First, it was not at all intentional. Daguerre had been a painter and composed his photographic shots as he would have composed paintings, not wishing to leave anything 'to chance' and indeed making copious references to the artistic tradition. But let us consider what will inevitably appear on the little copper plate. A particular table-cloth and an article of clothing are going to be there, before our very eyes, with their actual folds—those ordained by the chance arrangement of their material, not the painter's art. A person whose portrait is taken holds his arm in a way that hasn't totally been decided by the photographer either: hence an

element of chance shows through. In group photos, which proliferate once snapshots can be taken, that element becomes even more marked by the random arrangement of other bodies and their reciprocal positions, with no one now attempting to create harmony among these in a manner alien to existence as it is lived. And it won't be long before some cat the photographer neither planned nor wished for would walk into shot, which isn't something that could occur in any painting, despite the suggestion of it in Lotto's *Annunciation*. Chance is active in the photographic image; it deflects the mind from what the composition is saying, if there is composition; it shows that things exist as such, in a 'being-there' irreducible to mental activity. In painting, chance is sometimes simulated—by the very people who are trying to be rid of it. In photography, there is no need to simulate it; it is present from the outset.

It is legitimate to ask whether this really represents an invasion. But let us look reasonably closely at the most ordinary of photographs. Look at this pile of stones in it—most certainly there by chance—or the fabric of the jacket of someone who wanted to have their picture taken. In the photographic image, we see not only how these materials represent a complement to the idea of stones or jacket, but also the grain of these objects, if I may use that term—that accumulation of irregularities in the brute fact of the thing, the blotches, embryonic forms, folds or cracks that are indeterminate and practically infinite in number. In painting, an artist, guided by his idea and composing meaning, instituting it, would have controlled these details and might even have erased them with his touch and brushwork. In photography, by contrast, a free play of forms and forces, clearly beyond our laws and indifferent to our wishes, shows on the surface of

things—a profound, deep-seated refusal that *what is* levels against our pretensions to control it in the interests of a higher, entirely mental, reality. The element of chance here arises from the detail of what the camera perceives in the matter of the world, as much as it does from the relations that existed between the components of the work at the moment the photograph was conceived and taken. And, as such, it addresses the level of the intentions, plans and thoughts of the photographer and says to him what Mallarmé was shortly afterwards to admit to himself—namely, that we are 'but vain forms of matter'; that, in fact, we *are* not.

This is frightening. And it is also new. For the intuition of non-being was already in the air, most certainly—philosophy had always spoken of it or formulated it as a hypothesis; it had even, on occasion, asserted it as something self-evident—but it was so merely in the realm of thought and on the

margins of actual existence, whereas this plain fact was now being registered as close as could be to the creations of those who painted and drew, whose most steadfast intention had always been to deny it. Awareness of chance was henceforth most acutely present in our looking and at the heart of our thinking. If one perceives the element of chance in the lawyer's jacket and one then looks to the composition of his portrait, that composition, that product of the intellect, will appear as only one accident among others in entanglements of trifling events that are entirely unrelated. And this is sufficient in itself to relegate the image from providing an impression of reality to producing a record of unreality in an unlocatable, spectral dimension. This photographed room is no longer within the world of our actions, our acts. The drawers in its furniture cannot be opened, the vase on the table isn't there for any of us and these two people together, smiling It becomes clear why

the first photographers erased what they saw as useless detail from their work: they felt it to be dangerous. With Daguerre's invention, it was non-being that entered the previously closed field of the image.

In 1842, barely three years after Arago's announcement, just as long as it took for Daguerre's new invention to reach a wider public, Edgar Allan Poe, always in the forefront of the thinking of his day, published *The Masque of the Red Death*. In that story, in a castle shut up to prevent penetration by the plague,[4] a cause of death and, to an even greater degree, evidence of nothingness (a castle that is, moreover, the scene of a masked ball—a clear symbolization of what I term the image), the sickness still gets in beneath the external form of a mask or, in other words, of one part of the means deployed to combat it, now revealed in its true nature. The rejected element has just insinuated itself into that

which was trying to keep it at bay, thus testifying to its radically illusory character.

And what consequences immediately follow! For what becomes of the person who looks at the photograph, as he is now able to do? Like all the men and women around him in the castle where the orchestra falls silent, he is going to have to understand that he is merely one *montage* among others of those images that vainly reject chance, to understand that, right down to his most intimate sense of himself, he is this non-being. For if one of these images deconstructs, is it not obvious that all the others are together going to unravel? The looker empties himself out, ontologically speaking; if he allows himself, as indeed he must, to see the element of chance in the image, he cannot but register this emptiness within himself—though not, we should say, the emptiness of the night (in the positive, full sense of the mystical experience, in which the *nada*

is an excess of being) but the fact that the things of his days are now bereft of meaning and have each become a cupboard whose drawers don't open, a pure enigma, the inwardly collapsed outside of the inside of *here*. In that space of the self which, deserted by meaning, has become a stranger to itself, has become an *other of the self,* divesting it of selfhood. Hence the fear of going mad described in Maupassant's famous short story 'The Horla'.

IV

'Really?' the reader will say. Does this disaster really happen each time you view a photograph—or even a daguerreotype?

No, of course not. That wasn't the reaction of many of Daguerre's contemporaries or many of the first photographers, who even welcomed the new technique with enthusiasm. But I shall say, presently, that not all of them did so and I shall remind the reader here and now of the nature of a certain mode of communication called *insinuation* and of its history over the centuries. This involves ideas—or information—formulated in such a way that we may fail to form an awareness of them, or may refuse

to do so. But they lodge themselves in interstices of the great systems of representations and ideas that predominate in our conceptions of the world and of ourselves, and hence get through to our sub-conscious, which is precisely where these systems have their—never very firm—foundations. At that level, they act on us in a way that is initially little noticed, yet may in some cases be very intense and disproportionate to their apparent effect. When, as is the case here, such ideas function somewhere short of systems of thought and their associated scales of values, then distinctions of large or small cease to be operative. The tiniest sign or indication may be the thing that is most destabilizing.

Think of the person who is speaking—and growing frantic—in 'The Raven' by Edgar Allan Poe, to whose short stories I have already referred. Think, as Poe intended us to, of that student awake in a dark chamber of the mind, seeking in his

books—the bulwarks of a religious tradition—to allay his already deep doubts, who hears a scratching at his door, a very faint noise which nonetheless overwhelms him with unprecedented, unimagined terror. How disproportionate the relation between cause and effect! And think of that other insinuator, who has his place since the dawn of time in the everyday world of Christians, that Devil who slips almost imperceptibly into the world willed by God, with the destruction of faith as his chief goal. In each of these cases, it isn't some demonstration or argument, but a tiny flaw in the structures in place that leads to their collapse. Now, it is an event of the same, apparently imperceptible kind that occurs within traditional images when matter shows up there in all its brute nakedness as a result of photography. And one might even fear that this emergence may be of greater effectiveness than the Devil's insinuations, since the latter, as is well known, is only

allowed to attempt to lead astray. His cloven hoof shows beneath his duplicitous clothing. He hasn't actually gained access to the very idea of the world he wishes to discredit.

Insinuation is that tiny element that threatens beliefs and certainties with collapse. And, in case anyone is possibly not minded to follow me in these thoughts, I shall go beyond these long preliminaries and mention a number of facts which seem to me to provide evidence for them, since they can only have been effects of the darkness [*nuit*] that daguerreotypes and photography instilled into the image. Effects at the collective level, affecting the whole of society, and, consequently, for the most part, unconscious but perceptible and measurable in artistic creation or moral conduct. I believe it essential to take account of these events, some of them still ongoing, from the years that followed Daguerre's invention. They will enable us to gain a

fuller understanding of the disruption of which they themselves form a part, once we attend to what certain literary narratives, for example, say of them in their figurative way—that is to say, in a mode both conceptual and symbolic, and fuelled, as dreams are, by metonymy and metaphor.

V

With this, I begin the second part of my argument, though I am already quite a way through this essay and I shall only be able to indicate the broad outlines of the study I believe should be undertaken, a study of the effect of the photographic in various areas of human activity.

First, we should pay particular attention to the thought of Edgar Allan Poe and the work of Mallarmé, which, from this angle, develops and extends that thought, opening a whole, previously unexplored dimension within French language and literature. I have already mentioned 'The Raven', the great poem of 1845, the impact of which, as I very

much believe, can be partly explained by the way it transcribes into language the image as refashioned by the hand of Daguerre. But I shall not go back today over Poe's 'nevermore' or a number of his stories that, in various ways, reflect his dread of nothingness, nor shall I even turn to Mallarmé's 'Sonnet en -yx' or *Igitur,* even though these latter works are, for intellection, extremely important effects of the photographic. For it would take a whole book to gauge the significance, for example, of the phenomenology Mallarmé was attempting in *Igitur* of that announcement of nothingness that had just been made to the Western world.

Then we would have to note a number of social-life situations that attest to this impact, such as the following development, which the first great photographer Nadar noticed as soon as it occurred, with the critic Jérôme Thélot subsequently producing a remarkable analysis of Nadar's account. The event

in question was a murder and the role played in the public indignation at that murder by the photograph of the mutilated body. The idea of nothingness to which the photographic phenomenon gave rise within self-consciousness expanded its scope in these photographs by their presentations of the corpse, the dark underside of life, the epiphany of non-meaning. And, in return, the fascination aroused by the new kind of image showed up and made manifest this particular kind of consequence with as much curiosity as horror: we are at the beginning here of that lifting of visual taboos that would characterize the twentieth century. A disaster which would, literally, become one body with a press photography replete with scenes that even Assyrian or Aztec art would have censored; and also with pornographic photography. A disaster which would, nonetheless, assume a genuinely artistic form in certain practitioners of the photographer's art. We

ought to go back to see what was done by these gnostics of photography, who fully exploited the hint of darkness within it, though less with the aim of fighting it than of dreaming of worlds more luminous than our own—ways of taking up once again, with the new image, the metaphysical ambition inherent in the traditional one—and doing so openly this time.

Above all, however, we ought to take heed of the wave of resistance that arose—in this case openly and directly—against the denial of the experience of being, as constituted by photographic technique and the images it produced. It would be impossible to produce even a rudimentary history of photography if we failed to recognize the importance of these— in this case, wholly and fundamentally poetic— decisions which, from Nadar to Cartier-Bresson, and in many places since, have sought to provide being with a new kind of foundation in that very

place where the thinking of being was deconstructed. And to set against the nothingness that may be discovered in photography, when it deploys chance, the will to being that stands out clearly in that other apprehension of reality it makes possible, namely, the gaze, which was never previously perceived so fully and frontally in portraits as it was after Nadar's day. It is in reaction to its own pernicious insinuation that photography has been capable of works that entirely justify its being ranked on the same level among the activities of the mind as painting, which was in fact affected and deflected from its course by it at a very early stage. Not because photographs are able to reproduce objects with a precision and completeness which the most realist of painters cannot attain—that capacity is something that has interested only mediocre painters—but because they suggest we look elsewhere than on the paths of mimesis for ways to

think the human condition and its true needs. This was the case, for example, with Giacometti, obsessed as he was by the photos that lend weight to identity cards.

We should, at this properly ontological level, write the history of invention in photography, that history at times becoming a battle against the fascination that lures people down into its abyss. This history would follow the crest-line of the new times, doing so all the more—and all the better—for the fact that cinema has come to form absolutely essential links with this resistance. But this is much too enormous a field and I am going to confine myself today to a very tightly defined example, though one that shows up the primary effect of the photographic in a striking way.

VI

I am referring to 'The Night', a story Maupassant published in 1887, at around the same time as 'The Horla'. It is, in other words, a work from his last years—years that saw him descend into madness. The year 1887 may seem a very long way from 1839, and even from the beginnings of photography, but that is merely superficially the case, given that this new date is also the date of an event which is itself of great metaphysical significance and on almost the same plane as the earlier one.

That event is the use of electricity for public lighting at certain locations in Paris. And we need to pay attention to this under-examined aspect of

modern life—how the streets are lit, and with what. Public lighting plainly affects our relation to the world and our anxiety towards it very directly, since it confronts that darkness which the image—the traditional image—has always had the function of keeping at bay. And it does so in the name of our interests as civilized human beings—that is to say, at the heart of our cultural investments, and at the centre of the cities which, as such, are also products of image-based thinking. Battling against the darkness of the outside, it is fighting the same battle as the world-images of its age; it is, so to speak, in the front line in this ever-incomplete repulsing of nothingness.

Now, for a long time it had provided relatively effective protection in this regard. These were the days when lighting was done with candles. These latter, carried in the night-time, threw up shadowy figures, jerkily moving figures that could easily be

regarded as threatening or even frightening but were nonetheless interpretable using the knowledge, beliefs and, also, hopes available. Though arising at its edges, this was all still within the image society projected on to earthly locations. And, moreover, that light of candles and torches was too weak to eclipse the light shed by the stars or the moon, which had their place in this ancient experience of the world, connecting with the likes of draughts of air, fragrances and even colours. Which meant that the night, the fair night, could be appropriated to the truth of the day, and one might even be encouraged to find refuge in it, as Leopardi does with regard to the moon, imagining it as a friendly young girl who is all gentleness and understanding. The candle's flame throws a bridge between the unknown and the known; it is as reassuring as it is disquieting. It extends towards the outside world the myths by which convictions and beliefs are strengthened.

And this ambiguity didn't fade when gas made its appearance in the lighting of towns and cities, for its weak flame remained responsive to the wind; it had a life to it, animating shadows in which lovers or prostitutes concealed themselves with no great fear—all of which fuelled a very specific imaginary, present even in Mallarmé: in his 'Le Tombeau de Charles Baudelaire', the wick of the gas lamp is *louche*, which means that it looks to both sides of the mind.[5]

But electrical lighting was something quite different. First, electricity isn't a flame, such as would respond favourably to entreaties from the immediate environment, nor is it a form of combustion which could be ranged unhesitatingly among the natural processes from which image-worlds build up a part of their meaning. It is a modern substance, shorn of all myth and, similarly, remote from age-old thinking on the elements of water, earth, air or fire:

all in all, a positive denial of the light inherent in what was an overall conception of the world in which light was both the light of thought and the light of being. Moreover, by its intensity, both bare and decentred, electricity effects a violent but clean break between the world here and a night outside that is now felt to be entirely black, even though, on our avenues, that 'elsewhere' is very close by and is, indeed, almost *here*. Electric light offers up the night to our thinking as truly the other of *here*, of this being that is ours; it enwraps us in nothingness. And, in so doing, it corroborates what had been revealed by photography.

It is, we might say, as though it lifted the revelation out of its original frame, the photographic plate, and as though the city became the second frame, becoming itself a photograph and showing up now in three dimensions the same suggestion of exteriority, brute matter and chance. With Paris having indeed changed, even before Daguerre's day.

As I have tried to say elsewhere, in Baudelaire's century the Parisian crowd lost its vesture of signs and emblems that made it, before the Revolution, a manifestation of the image of the world in its hierarchy of functions and figures. The human environment became anonymous there; it was something neutral now, something sadly unknown and, similarly, the network of church porches and statues ceased to be instructive and overflowing with meaning: there was everywhere, if not a declaration of non-being, then at least a disposition to listen out for such a declaration. Paris, which would soon be photographed magnificently—think of Marville, and later of Atget—was already, in that new age, the pendant to the upcoming insinuations of the photographic plate. And electric lighting merely confirmed those insinuations by making them more immediately perceptible.

1887–88 is, then, the second time the photographic makes its impact, the time it spreads into the streets and society by way of electric lighting. And that lighting, we may note at this point, is mainly installed on some of the major boulevards, in precisely the places where a kind of perpetual party atmosphere had been established—in the cafes and the theatres—for those who wanted, as they say, to deaden their senses. This is in some ways the situation of *The Masque of the Red Death*. Paris and life in Paris became both scene and message. They are something to ponder over, these dialectics of the so-called City of *Light*.

VII

And pondering, pondering over Paris, pondering over this 'Now that is the Night'[6] is what Maupassant did in the short story I am going to address next. In 'The Night' (where they are virtually made explicit), we may follow both the successive moments and one of the possible conclusions of this development of an awareness of non-being experienced as non-meaning.

To begin with, these few pages are a reminder of the characteristics of the night as it used to be experienced in cities that had, as yet, little lighting: the 'gentle night' of Baudelaire's poem,[7] where fears were more calmed than aroused and where the—at times

light and enveloping—shadows could be regarded as benign; a night for which Maupassant, at least, expresses a very great liking. We are looking here at 'yesterday', in particular ('was it yesterday?—yes, surely, unless it was before that, another day, another month, another year'), and we may take him to mean a time that is now finished, since which point 'the sun hasn't reappeared'. Yesterday everything was, indeed, clear in the mild night air and 'I gazed up at the black river flowing above my head, the black star-studded river framed in the sky by the roofs of the buildings in the winding street.' At this beginning of the story, we are in the presence of night such as it was shaped by the all-embracing image of the world produced by conceptual thought—a margin within being, not its denial.

Then—and this clearly runs in the same direction as my present thoughts—Maupassant begins to rove around the boulevards, where the cafes are

'ablaze', where people are laughing and drinking, singing or shouting, and at that point he becomes aware of the excessive intensity of their lighting— the lighting produced by electricity. Beneath the 'electric globes, like pale but brilliant moons or lunar eggs fallen from the sky or monstrous living pearls [. . .] the chestnut trees, smeared with yellow light, seemed painted'. A very discerning vision of the starkness of these new perceptions which disperse into the mere appearance of things what it was that made them analogies for human life; and which strip the colours from them, as though these weren't the simple, happy emergence of their particular natures, but that pure exteriority that is blindly registered by the photographic machine.

And, quite logically, the narrator of 'The Night' then leaves the city to take refuge in a place that is unlit and hence still natural—in this case the Bois de Boulogne, where he stays for 'a long, long time'.

Yet he fails to recover his peace of mind. 'I had been gripped by a strange thrill, a powerful, unexpected emotion, an intense mental excitement verging on madness.' Are not this excitement and this madness, presented here as the consequence of electric light, the effects on the mind of the revelation of nothingness effected by photography and confirmed by electricity—that effect that will also be expressed by the 'horla' of the other story at almost the same time? We have here an 'emotion' that was definitely 'unexpected' at the beginning of the evening. An agitation of the mind writhing in horror at the catastrophic loss of its bearings.

I feel justified in believing that a sudden awareness of this particular kind is at issue, since, just after it happens, there comes the return into Paris, where the most astonishing event conceivable by which to represent that horror to oneself occurs. The narrator passes through the Arc de Triomphe and is now on

the Champs-Elysées, but first—and in a more pro-
nounced way than before he left the city—we have
once again this impression of colours acquiring a life
of their own and reducing to nothing things whose
colour actually specifies their identity. On an
avenue, there is 'a line of vegetable carts on their way
to Les Halles'. And Maupassant observes: 'They
were moving slowly, laden with carrots, turnips and
cabbages [. . .]. At each pavement light, the carrots
showed up red, the turnips white and the cabbages
green. And the carts went by one after the other, red
as fire, white as silver, green as emerald.' Appearance
has become detached from life, and form dissociated
from meaning. Sufficient grounds already to see the
buildings as mere facades with nothing behind
them.

And then there are streets, more streets, avenues,
which are extraordinarily—even incomprehensibly
—empty, completely empty of passers-by. Space,

which is simply itself and which, in itself, is nothing, has invaded life through the insides of its words, of its attributes; it undoes life, dissipates it. What the man we are listening to more and more attentively discovers, what we see him moving into, is an entirely deserted Paris, where at first he encounters just a few stragglers hurrying home, after which he will see only unlit cafes, extinguished street lights, places with not a single person in them in a night growing darker and darker, where this sole remaining living being has to grope his way along. And he goes along haphazardly, continually getting lost but realizing now that there is no re-finding his way, no safe haven to return to. Places he recognizes as he passes —the Château d'Eau, the Crédit Lyonnais, the Stock Exchange—are eyes that are closed, but clearly not closed in dreaming. And he is amazed, so natural is it in this world to want explanations for everything. But terror rapidly overtakes him and he yells,

though no answer comes; he utters a cry for 'help' which he knows to be laughable.

And now he is suddenly asking himself, 'What time is it?' Won't time, which is memory, thought, project and properly human reality, save him from this drifting and anchor him in a reality? All remaining hope is now located in this point outside of space—his watch. 'I listened to the gentle ticking of its workings with a strange, unfamiliar joy. It seemed alive,' writes Maupassant, 'I wasn't so alone.' It is quite natural that it should be time that helps him extricate himself from this lifeless space which renders even the starry sky black—'blacker even than the city'. Feeling his way along the walls with his cane, as a blind man might, he rings hopefully at a door.

But the sound of the bell in the house is such as to suggest that there is nothing but that noise alive within. And ringing once more without getting an

answer, he is afraid, very afraid, and runs to the next house. And the next and the next, their doors remaining closed to him despite his shaking. And so the hope his little watch had brought him subsides. Moreover, 'No clock struck the hours, either on the church towers or the public buildings. I'll open my watch-glass, I thought, and feel the hand with my fingers. I pulled out my watch . . . it wasn't ticking . . . it had stopped.' With this discovery, we feel that his end is nigh. Except that now he is down by the river and feels a 'glacial chill' rise to meet him. And he asks himself, this assuredly being the most anxious of all his questions: 'Was the Seine still flowing?'

VIII

Let us pause over this question. It seems to me that the whole experience of 'The Night' is condensed in it, but with an additional element not formulated there, though I believe that is something we can recognize and ponder over.

What is the Seine here? It is alone in having the better part of its life outside the city. And when we have noted the destruction of meaning in Paris, don't we have to ask ourselves whether that urban *here* isn't just a kind of bad dream—a 'nightmare', the subtitle of the story—from which we would awaken if we travelled up-river? Our network of mere surface thoughts is perhaps just the nocturnal

flip side of being in the world. And *out there*, in a place that is purely natural, a truer meaning perhaps has currency, which would restore life to the *here* that is now merely a place of vain imaginings. It was already with this idea that Maupassant—the fiction he invents scarcely provides him with a veil—had sought refuge, instinctively, in the Bois de Boulogne. In short, doesn't nature have resources that are forgotten in those places where the cafe-concerts, for example, are 'like so many hearths amid the foliage'? It is certainly true that nature herself has been infiltrated and corrupted by our late language. But it may also be that at some crossroads in a wood a path may yet open up with a true light still burning in the distance . . .

Sadly, the river's reply to the question from the man who is now down by the waterside merely seems to confirm what this empty, silent Paris around it is saying. And it actually does so in a way

that is as terrifying as it is, once again, unexpected. Is the river flowing? 'I wanted to know,' writes Maupassant. 'I found the steps and went down . . . I couldn't hear the current roiling beneath the bridge's arches Still more steps . . . then sand . . . then mud . . . then water. I dipped my arm in . . . it was flowing . . . flowing . . . cold . . . cold . . . cold . . . almost frozen . . . almost exhausted . . . almost dead.' What is signified by the river running dry like this, by this great chill? That the absence of meaning prevails as much in the realm of nature as in language. That there is nothing to be hoped for from this universe plunged in the darkness of night. And for the narrator it means understanding that he won't have the strength to come back up from the quayside. It means knowing—these are the last words of the story—that he will die there 'of hunger . . . fatigue . . . and cold'. Words that seem, indeed, to form the basis for the totally pessimistic intuition

that has led, through surprise and horror, to these waters whose flow is coming to a halt.

Words that are the ending of 'The Night'. But do I, its reader, have to come to the same conclusion? I am, in fact, amazed. The Château d'Eau, the Stock Exchange, the markets of Les Halles had risen before us, frozen in their mere appearance, pure exteriority, though none of the details of their ordinary form were lost. It was even this completeness which, gathered there to no purpose in the general silence, had provided the heart of the horror. And if the green and red of the carrots and cabbages seen at first had, indeed, a kind of autonomy, their light rays turning all these vegetables into simple though terrifying images, they nonetheless preserved their minutest features in the market-gardener's cart. 'The Night' is essentially this collapse of meaning in something which retains its appearance. So why is it not the same with the river? So close to all these

places and things 'frozen' in their *being-there*, why is the Seine itself not also complete in all its—transfixed and yet preserved—appearance? How terrifying it would be to see it both flowing and not flowing, its whole great regular flow frozen to a standstill! This would be both the climax of the ever-expanding vision in 'The Night' and yet, as we may note in passing, also what photography—mere run-of-the-mill photography—does to the vibrancy of life.

At the end of 'The Night', the Seine isn't the ghostly entity that Daguerre and the first photographers presented us with as a substitute for lives. The author wanted nothing of this vast flow, this foaming swell against the arches of the bridges which, mysteriously muted like time in the watch, would have been the great horror in the story; instead, he replaces it with the running-dry of the river, which at this point expresses, as though in

words, what the Château d'Eau or Les Halles or the colours green and red had themselves demonstrated against a backdrop of silence.

But this substitution is highly meaningful. Does it really bring confirmation, in this new way, of the declaration of nothingness made by the rest of the city? No, we should rather see matters as follows. This water, which signifies non-being rather than showing it, is therefore an instance of signification— one further signification, at the farthest end of this world which had ceased to have any. It is speech amid the aphasia that seemed to be the basis of everything. And though this signification, admittedly, bespeaks death, we are talking this time of ordinary human death, the death to which a man suffering hunger, tiredness and cold resigns himself. What are we to conclude? That Maupassant, despite his terror, has succeeded by means of a metaphor— that constant resource of human speech—to wrest

from non-meaning a scrap of meaning. Now, that meaning is entirely negative, it is a cry of despair. But, black as it may be, it is a signification nonetheless. Even at the last moment, speech will not have abdicated its role.

Might it be that we cannot step outside of meaning? That the only experience of a withdrawal of meaning comes in and through an ever-continuing life of language? But if that is how things are, must we really accept the clear fact it believes it registers, because of the accumulation—'vain walls' said Mallarmé; 'Unreal City' echoed T. S. Eliot[8]—of so much damning evidence?

IX

I ask myself this question and, in doing so, I find myself back at photography—if, indeed, I ever left it.

This Maupassant who writes 'The Night' is someone I can properly call a photographer. These streets and monuments, as they unfurl themselves in silence, are nothing more in his eyes than their inscription in space. And that is precisely what the photographs of his day presented us with—those photographs printed in white and grey with no hint of colour or atmosphere. Reading Maupassant, even when he speaks of the carrots or turnips in the market-gardeners' carts, we think of such work as

Eugène Atget's, who was barely thirty years old that year. Atget, who also shows empty streets, silent 'vain walls', ghostly displays of wares in a light that may be the light of dawn, of misty day or of endless night—of day worn down by night.

And Maupassant is also a photographer in the way so many professionals were in his time, because, for all that his novels and stories abound with evocations of men and women wrested from the whirl of life by his psychologist's and sociologist's eye, they are nonetheless as deserted as a daguerreotype is on its silver surface. This singular body of work teems with figures but, for want of affection for his characters on the part of the storyteller, we don't meet any presences in its pages. Arriving from his native Normandy the way the narrator in 'The Night' arrives back from the neighbouring wood, with a ready-formed mastery of language camera-like in its precision, he too entered Paris without encountering

a living soul. His experience of human beings is the perception of the grain of their skin and a magnification of features which mean that his supposed realism veers towards that same withdrawal of meaning, that same latent fantastical vision as the monuments we come upon in 'The Night'. And on all this there falls, like a night-time chill, a pessimism that rendered him familiar from the outset with fumblings forward in the dark. The sky is empty above him; values seem mere fancies, lives mere solitudes.

But is this actually true? Wasn't Maupassant capable, deep down, of another way of seeing and, by that very token, of an anxiety about others—other human beings—which his existential choices failed to allay? We are entitled to believe so, since his last writings speak of the experience of a presence, even if that presence—the 'horla'—is inaccessible, hostile and negative, and even if it prompts in him such desperate horror and renunciation as was

felt by the narrator of 'The Night' as he ended up down beside the river. Maupassant hasn't met the gaze of the 'horla'; he is going to die. But in that absence he felt a foretaste of, and a sense of regret over, the presence he hadn't been able to desire earlier in his life.

And what comes back to me, in the light of that other tale from his last days, is the feeling that I haven't understood everything about the last lines of 'The Night', the impression that, in this river running dry, a reality of a quite other nature is surfacing and yet eluding me for a reason that is perhaps as crucial as can be. What was this weak current, this growing chill, this sand and silt mingling as they did, with that already 'almost dead' water the way that, in Goya's *The Dog*, the same silt and sand put a final end to a life whose astonishment is entirely summed up in its last gaze?

Well, this water, of which Maupassant asked whether it was still flowing, this water which would run dry without ever having ceased to be the water we so needed—eternal water—is, as I now understand, life which, like the dog in the great painter's thinking, perceives, at the moment everything is falling apart, that it could have had being. And how could that be, in such utterly dark night, except by way of a gaze that would have recognized it and welcomed it in—and as—shared time? This almost dried-up flow is an existence which, becoming aware of itself, is essentially that gaze which seeks to encounter and hold another's—something which would at a stroke establish another reign than that of mere matter. And in this Maupassant, who dies from not having known this earlier, there is, as in the more lucid Goya, the sudden memory of that human being that he ought to have encountered at least once, instead of constantly wandering aimlessly in

the crowd—that human being who was mortal like him, thus making the meeting that failed to take place an irreparable loss, a death-in-life more real, destructive and hope-sapping than the death that puts an end to him.

What is Maupassant doing in the last words of 'The Night'? In the unreality of everything, he is at last becoming aware of the reality of the Other's gaze. Aware, in this world emptied of self by the apprehension of nothingness, that there is a possible being: to be convinced of this and to accede to it, it is enough to move to empathize with those who share with the person one potentially is the condition of the dog buried deep in the sand in Goya's painting. What have we to do with nothingness, since we are mortal? Since, out of infinite astonishment, which could become despair, we can create the site of a decision to recognize and to share? At the darkest point of 'The Night', Maupassant

spotted this glimmer of light—that we may recognize the powers of finitude and, employing this key, move on to new ground. Alas, for him it is too late; he feels he lacks the very bodily strength to do so.

But in his way he bears witness, and to do so is also to shed light on that photography of his time which, like him, allows itself to be overwhelmed by the false proofs of non-being, but might, in its case, recover itself, if indeed it hasn't already begun to do so here and there. In the century of Daguerre and Atget, which was also Nadar's century, 'The Night' is what best enables us to understand the events of the first photographic era in their future-laden dialectic. First, we should ask what else these eyes did—the eyes which, in the work of Daguerre and then of others, perceived chance, the outside of things, the vanity of metaphysical dreams and the death of God—than enter the darkened, deserted city, like the Maupassant of 'The Night', and stroll

around in it for hours. But, again like him, perceiving that in this frozen world water still flowed, in the case of some of the photographers of that age, those same eyes, which had nonetheless remained human, opened up to a deeper level of reality.

How were they able to do so? Well, I now see on the photographic plate another kind of first, deeply moving apparition than that which put an end, in Edgar Allen Poe's story, to the eternal masked ball of what I call the image. What did we see in so many paintings by painters such as Titian, Franz Hals, Rembrandt, Goya, even Van Gogh and Giacometti, who came upon the faces of so many men and women and turned those faces towards us? The eyes in those works are full of thoughts and emotions and we can read intentions in them; often the painter even succeeds in rendering the pain and compassion visible in those faces, but the look in their eyes isn't real, because when our eyes meet real

gazes in our lives, in the street, they contain not only what we can read in them but also an obvious unknown element we cannot fathom. What is this person exactly, what is he planning, what at this very moment is he just beginning to grasp? It is a whole excess element in the person which we sense with our own eyes, but cannot fathom in the slightest, and which it will be impossible to depict in a painting—even a portrait—since works are, to their very depths, only what their creators know or feel or wish to make. Some artists have understood this and tried to push beyond the mysterious limit, but to no avail. In their works we find at best the idea of a gaze, but not that unfathomably individual gaze that emanates from a real person. The image as we have known it over the centuries is incapable of opening itself up to the gaze, that expression of finitude.

But what of the new image, the photograph? Here, very much to the contrary, it is the real gaze

that is captured and presented in the least significant photograph we take of someone, the moment they turn towards us. No longer is this something imitated, the outcome of an incomplete analysis that would lack the knowledge of finitude; it is a real presence, and a presence all the livelier for the fact that this time there is perceptible in the image what the photographed individual has in them that is unbeknown to us or even that remains unthought in their own relationship to themselves. The photograph, which expresses non-being through its perception of chance, is also—and it is unique in this—what puts us in the unmediated presence of beings other than ourselves: in the presence of their presence. And the fact of the great saving exchange (or even the need for it) which Maupassant seems ready to recognize at the end of 'The Night'—an exchange he is regretfully unable to experience in his own life—is something photography can remind us

of through its own particular resources. It can even attempt to bear testimony to it itself.

And this indeed did occur. What were Nadar and Carjat doing but seeking out the gaze of Baudelaire, of Marceline Desbordes-Valmore, of Rimbaud? It wasn't that they wished to speak to us *about* these poets; they were intent, rather, on speaking *to* them. It wasn't their aim to discover what this sorrowful man was, or this aged woman, or this young boy at the stormy dawning of his self-awareness; rather, they registered the fact of their existence, they detected the—anguished or confident—summons which existence always is. And, in that way, they were beginning the resistance which, as time went on, ranged a number of photographers—clearly, the greatest of them—against the pernicious promptings of their practice. Promptings and incitements to spiritual abdication, which were veiled—and yet rendered even more dangerous—by the snapshot

and by colour. This is the standpoint from which the history of twentieth century and subsequent photography should be written.

In conclusion, I shall simply mention a poet who criticized photography solely from an intuitive sense, as I see it, of the destructive effects of that realism which his contemporaries liked about it. When one thinks of 'The Night', Baudelaire inevitably comes to mind. He too walked in Paris with a certain inclination not to encounter real existences. When he presents himself as the observer of the passers-by he spots in the crowd—and as able to read their cares and their dramas—he actually manages only to project his own cares and categories of thought on to them; he substitutes a schema for what might have been a fuller presence, in which case the person concerned would have had an opportunity to respond to the other's idea, to react. And it is doubtless this subservience he desires, out

of a lack of courage to confront what he calls 'the tyranny of the human face'.[9] All things considered, he employs his intellect to override his truest need. And he can dream then of a Paris that would help him soothe his painful fear of the other thanks to the night, with its sparser throng, a night he even sees—'At One O'clock in the Morning'—as somewhat similar to the night Maupassant imagined. 'Alone, at last! Nothing to be heard now but the rumbling of a few belated, weary cabs . . . At last! I am able to relax in a bath of darkness!'[10]

Yet is the 'gentle night' he desires as beneficial as he wants to believe? Is it not, as such, a dream that exposes him, in its very bosom, to some terrible awakenings? I am struck by the analogy that exists more deeply between Maupassant's text and some pages from Baudelaire. In 'Parisian Dream', that dream of Paris in Paris, the issue is no longer the desertification by rigidification of the streets and

facades that was so overwhelming in 'The Night', but the multiplication to infinity—in a world of nothing but stone and metal, with no vestige of sun or moonlight, in a 'silence of eternity'—of the colonnades, the 'sheets of water', the cascades; and it is, further, the disintegration of the ordinary sites of life, the same triumph of space over the time inherent in real existence. The bad dream has merely increased the fear at having to live. And through these 'vast buildings'[11] and these labyrinths, there can be heard the creakings of an imminent collapse. 'How to warn people? . . . ' Baudelaire wonders in that other dream narrative, 'Symptoms of Ruin', which he planned to add to his *Spleen de Paris*— though it is undoubtedly he himself who needs the warning. He is the one in danger of sinking into non-being by dint of his—recurrent—temptation to 'double lock' his door and cherish loneliness.

The fact remains that Baudelaire is a poet; at every moment, in his voice—and in the words that voice conveys—there wells up, to surprise him and also to send him back to life, the thought of evening sunlight, of 'the glow of coals' in the hearth, of the 'mother of memories', with a woman present beside him for better or for worse.[12] And it is this unshakeable attestation of the Other—poetry, great poetry, the kind that eschews dreaming—that will, remarkably, change his relationship with Paris and, down beside the Seine again, lead him back from the passion for the night to what Karl Jaspers calls 'the norm of Day'. I shall not dwell on 'The Swan' again here, inexhaustible as that poem may be, but I shall simply note that time, which had evaporated from Maupassant's empty city and had returned only as something black and terminal in 'Symptoms of Ruin', has resumed its course in 'The Swan'—and in its social being—since we are told there that 'Paris

changes'. And it is a change that troubles Baudelaire: the end of 'old Paris', a building-site of soulless avenues, an inert mass of scaffolding and stones with a further risk that time will freeze. With it, Baudelaire stokes his 'melancholia', but self-conscious melancholia is a lesser evil than death installed in the heart of life, and Baudelaire, reborn to himself, can achieve a genuine encounter, whereas Maupassant in 'The Night' will only be able to dream of that deliverance.

I shall turn from 'The Swan' now to another poem. In 'To a Passer-by' Baudelaire is again walking in Paris, as he did so often, perceiving instinctively that this progress around the city was the ordeal he had to conquer. And Paris on that day too is in danger of merely being a tableau of nothingness, since the street mentioned in the first line is 'deafening' and even 'roars'—the roar of a noise that makes it as much of a desert as the tomb-like silence

of Maupassant's night-time city. But it is at this point that Baudelaire rises, directly and explicitly, to the idea of meeting, of exchange and also, and perhaps most importantly, the idea of the conditions in which that event occurs. The other, in this instance, is that which, the moment before—and as ever— might simply have appeared veiled by the prejudices of the dreaming self, substituting the—fundamentally aesthetic—flatness of the image for the three dimensions of lived experience: and, indeed, the woman who is the poem's passer-by is described as 'agile and noble' with a 'leg like a statue's'.

But she is also 'in deep mourning' and we are not to make a work of art of her but to get up close to her life, sense the suffering in it, recognize it as a finitude; it is on this level that real encounters take place. Now—and this point is at the heart of the poem—Baudelaire reports that this meeting was an exchange of glances, which was sufficient to 'bring

him back to life', to gather up within him the real, which is never anything other—or anything more— than the desire to be in the world. A glance, a light- ning flash. And after the lightning flash the night perhaps once more, though for the duration of the lightning, which has no end, all the rivers and all the skies and all the beings in the world.

The glance a lightning flash. The light in which this world appears, which only the moment before was in darkness. Nadar was quite right to seek out and respect the gaze in the man or woman he photo- graphed. That gaze, brimming with its unknown element, was enough to remind us of the potential that remains alive in a seemingly dead reality. It was enough to preserve the invention of the photo- graphic from exerting its potential deleterious effects. It was no longer the ghostly exterior or the nothingness entering the masked ball, but the fresh air of morning, as the—so often ineffectual—lights of the chandeliers were going out.

Notes

1 The reference is to Stéphane Mallarmé's text, *Un coup de dés jamais n'abolira le hasard*, first published in 1897 in the multilingual literary review *Cosmopolis*.

2 'Delacroix, lac de sang hanté des mauvais anges' [Delacroix, lake of blood haunted by bad angels]. Charles Baudelaire, 'Les Phares' in *Les Fleurs du Mal* (Paris: Poulet-Malassis et de Broise, 1857), pp. 23–5.

3 The concept of 'crystallization' figures prominently in Stendhal's essay *De l'Amour* (Paris: Mongie, 1822).

4 In the American original, Poe specifies that the building is a castellated abbey.

5 The verb *loucher* literally means to squint.

6 The reference is to Hegel's phrase 'Das Jetzt, welches Nacht ist'. See G. W. F. Hegel, *Phenomenology of*

Spirit (A. V. Miller trans.) (London: Oxford University Press, 1977), p. 60.

7 'Entends, ma chère, entends la douce Nuit qui marche' [Hear, my dear, hear the tread of gentle night]. Charles Baudelaire, 'Recueillement' from 'Les nouvelles fleurs du mal', *Les Fleurs du Mal* in *Œuvres complètes de Charles Baudelaire*, VOL. 1 (Paris: Michel Lévy frères, 1868), p. 239.

8 The first phrase occurs in Mallarmé's 'Toast funèbre', the second in Eliot's *The Waste Land*.

9 'Enfin! la tyrannie de la face humaine a disparu . . . ' Charles Baudelaire, *Œuvres complètes de Charles Baudelaire*, VOL. 1, p. 287. Baudelaire apparently borrows this phrase from Thomas De Quincey.

10 Ibid.

11 Charles Baudelaire, *The Prose Poems, with 'La Fanfarlo'* (Rosemary Lloyd trans.) (London: Oxford University Press, 2001), p. 115.

12 'L'ardeur du charbon' and 'Mère des souvenirs' are phrases from Baudelaire's poem 'Le Balcon' in *Les Fleurs du Mal* (Paris: Poulet-Malassis et de Broise, 1857), pp. 81–2.

APPENDIX

The Night

Guy de Maupassant

TRANSLATED BY CHRIS TURNER

I love the night passionately. I love it the way you love your country or your mistress, with a deep, instinctive, indomitable love. I love it with all my senses: with my eyes that see it, my sense of smell that breathes it, my ears that hear its silence, the whole of my body that is caressed by its darkness. Skylarks sing in the sunshine, the blue air, the warm air, the light air of clear mornings. The owl flees into the night, a dark smudge travelling through dark space; delighted and thrilled by the black vastness, it sends out its quivering, sinister cry.

The day tires and bores me. It is coarse and noisy. I rise with difficulty, dress wearily, leave the house reluctantly and each step, movement, gesture, word and thought is as tiring as if I were shouldering a crushing burden.

But when the sun goes down, my whole body fills with a strange joy. I wake and am full of life. As shadows lengthen, I feel quite different: younger, stronger, happier, more alert. I watch the darkness thicken, that great gentle darkness that falls from the heavens. It engulfs the city like an unfathomable, impenetrable wave. It hides the colours and shapes; blots them out; destroys them. It enfolds houses, monuments and creatures in its imperceptible embrace.

And then I want to hoot with pleasure like the owls, to run over the roofs as cats do, and my veins are suddenly alive with an impetuous, invincible desire to love.

I go walking, at times in the darkened suburbs, at times in the woods around Paris, where I hear my sister animals and my brother poachers prowling.

What you love violently always ends up killing you. But how am I to explain what happened to me? How can I even convey how I am able to tell it? I don't know. I don't know any more. I know only that this is the case. And there you have it.

So yesterday—was it yesterday?—yes, surely, unless it was before that, another day, another month, another year—I don't know. Yet it must be yesterday, since the dawn hasn't broken since, the sun hasn't reappeared. But how long has the night lasted? How long? Who will say? Who will ever know?

So yesterday I went out, as I do every evening, after my dinner. It was very fine weather, very pleasant, very warm. As I went down towards the

boulevards, I gazed up at the black river flowing above my head, the black star-studded river framed in the sky by the roofs of the buildings in the winding street, which caused that rolling stream of stars to meander like a real river.

All was clear in the mild air—from the planets to the gas lamps. There were so many lights up there and around the town that even the shadows they cast seemed luminous. Bright nights are more joyful than long sunny days.

On the boulevard, the cafes were ablaze; there was laughter, bustle, drinking. I went into a theatre for a few moments, but which theatre I cannot recall. It was so bright that I was saddened by it and I came out a little downcast at the shock of the harsh light on the gilding of the balcony, the artificial sparkle of the enormous crystal chandelier, the glare cast by the footlights, the melancholy of this harsh, fake brightness. I reached the Champs-Élysées,

where the cafes-concerts seemed to glow like so many hearths amid the foliage. The chestnut trees, smeared with yellow light, seemed painted; they looked phosphorescent. And the electric globes, like pale but brilliant moons or lunar eggs fallen from the sky or monstrous living pearls, made the dirty, ugly gas filaments and the garlands of coloured glass pale beneath their mysterious, regal, pearly brightness.

I paused beneath the Arc de Triomphe to view the avenue, the long, wonderful starry avenue leading toward Paris between two rows of lights, and the stars! The stars in the sky, the unknown stars scattered randomly about the vastness of space, where they form those bizarre patterns that have given rise to so much dreaming and reverie.

I went into the Bois de Boulogne and spent a long, long time there. I had been gripped by a

strange thrill, a powerful, unexpected emotion, an intense mental excitement verging on madness.

I walked for a long, long time, then came back.

What time it was when I passed back through the Arc de Triomphe, I don't know. The city was falling asleep and clouds, great black clouds, were slowly stretching across the sky.

For the first time, I felt that something strange, something new was going to happen. It seemed to me that it was cold, that the air was thickening and that the night—my beloved night—was beginning to lie heavy on my heart. The avenue was deserted now, but for two policemen walking by the cab rank. And on the roadway, now only faintly lit by the seemingly dying gas lamps, there was a line of vegetable carts on their way to Les Halles. They were moving slowly, laden with carrots, turnips and cabbages. The drivers were asleep and unseen; the horses, following the cart in front, walked noiselessly

and with an even tread on the wooden paving. At each pavement light, the carrots showed up red, the turnips white and the cabbages green. And the carts went by one after the other, red as fire, white as silver, green as emerald. I followed them, then turned off into the rue Royale and came back to the boulevards. There was no one about now, no lights in the cafes, just a few stragglers hurrying along. I had never seen Paris so dead or deserted. I pulled out my watch. It was two o'clock.

A force was driving me, a need to walk. So I went as far as Bastille. There I realized I had never seen a night so dark, for I couldn't even make out the July Column, the gilded 'Spirit of Freedom' that tops it being lost in the impenetrable darkness. A vault of cloud, thick as the celestial vastness, had swamped the stars and seemed to be descending upon the Earth to annihilate it.

I came back. There was no one around now. Yet at the Place du Château-d'Eau a drunkard nearly collided with me, then vanished. I could hear his uneven, resonant tread for quite some time. I walked. As I reached the Faubourg Montmartre, a cab passed by going down towards the Seine. I hailed it. The cabman didn't reply. A woman was prowling about near the rue Drouot: 'Monsieur, listen.' I hurried on to avoid her outstretched hand. Then, nothing. Outside the Vaudeville Theatre a rag-picker was scrabbling in the gutter. His little lantern hovered along the ground.

'What time is it, my good man?' I enquired.

'How should I know?' he grunted. 'I don't have a watch.'

Then I noticed suddenly that the gas lamps were out. I know they put them out early, before dawn, at this time of year as an economy measure. But dawn was still so very far off!

'Let's go to Les Halles markets,' I thought. 'There, at least, I shall find some life.'

I started off, but couldn't even see well enough to find my way. I made slow progress, as one does in a wood, recognizing the streets by counting them.

By the Crédit Lyonnais, a dog growled. I turned down the rue de Grammont and got lost; I wandered around, eventually recognizing the Stock Exchange by the iron railings that surround it. The whole of Paris was sleeping a terrific, deep sleep. And yet in the distance a cab was going along, a single cab, perhaps the same one that had passed me not long before. I tried to reach it, moving towards the sound of its wheels, through lonely streets that were black, black, black as death.

I got lost again. Where was I? What madness to turn the gas off so early! There was no one in the street, no straggler or prowler, not even the mewing of an amorous cat. Nothing.

Where were the police? I thought to myself, I'll shout out and they'll come. I shouted, but no one replied.

I shouted louder. My voice vanished without echo, weak as it was, stifled and crushed by the night—by that impenetrable night.

I yelled: 'Help! Help! Help!'

My despairing call met with no response. Whatever time was it? I pulled out my watch, but I had no matches. I listened to the gentle ticking of its workings with a strange, unfamiliar joy. It seemed alive. I wasn't so alone. What a mystery! I set off walking again like a blind man, feeling along the walls with my cane and lifting my eyes constantly to the sky, hoping that daylight would eventually appear; but that space was black, totally black, blacker even than the city.

What hour could it be? It seemed to me I had been walking for an unconscionable time, as my legs

were giving way beneath me, my chest was heaving and I was horrendously hungry.

I made up my mind to ring at the first door I came to. I pulled on the brass knob and the bell rang through the echoing house; it rang strangely as though this resonant sound were alone in the house.

I waited. No one answered, no one opened the door. I rang again and waited again. Nothing.

I was afraid! I ran to the next house and at twenty others in succession I rang bells in the dark corridors where the concierges should have been sleeping. But they didn't stir. And I went further, pulling on the rings and knobs with all my strength, banging on the obstinately closed doors with feet, cane and hands.

And suddenly I realized I was coming to Les Halles. The markets were deserted. There wasn't a sound, a movement, a cart, a man, not a bundle of

vegetables or a bunch of flowers. They were empty, still, abandoned, dead!

I was seized by a fearful sense of horror. What was happening? Oh, my God, what was happening?

I set off again. But the time? The time? Who would tell me the time? No clock struck the hours, either on the church towers or the public buildings. I'll open my watch-glass, I thought, and feel the hand with my fingers. I pulled out my watch . . . it wasn't ticking . . . it had stopped. There was nothing, nothing—not a tremor running through the city, not a glimmer of light, not a rustle of sound. Nothing! Nothing! Not even the distant trundling of a cab—nothing!

I was by the quays now and a glacial chill rose from the river.

Was the Seine still flowing?

I wanted to know. I found the steps and went down . . . I couldn't hear the current roiling beneath

the bridge's arches . . . Still more steps . . . then sand . . . then mud . . . then water. I dipped my arm in . . . it was flowing . . . flowing . . . cold . . . cold . . . cold . . . almost frozen . . . almost exhausted . . . almost dead.

And I could feel that I would never have the strength to get back up again . . . and that I too was going to die there—of hunger . . . fatigue . . . and cold.

14 June 1887

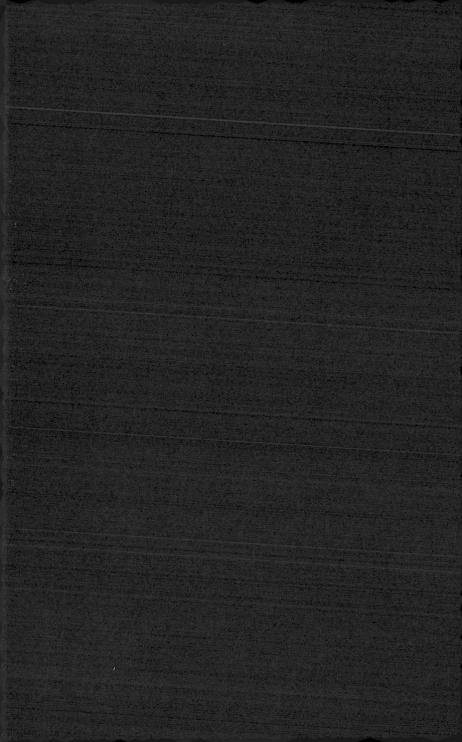